THE FRUITFUL DIS
OF THE WO

LAWRENCE DURRELL (1912–1990) although best known for his novel sequences (such as *The Alexandria Quartet* and *The Avignon Quintet*) and his 'travel' writing (such as *Prospero's Cell*, *Reflections on a Marine Venus* and *Bitter Lemons*) considered himself first and foremost a poet.

PETER BALDWIN, a retired solicitor, has supplemented his collecting of Durrell's work by publishing under his Delos Press imprint two original works by Durrell: a fully revised version of Durrell's play *An Irish Faustus* and a short essay *Henri Michaux: The Poet of Supreme Solipsism*. Peter has also written and published widely on Durrell.

ALSO AVAILABLE FROM COLENSO BOOKS

Conon's Songs from Exile: The Limited Edition Publications of Lawrence Durrell
by Peter Baldwin (The Delos Press, 1992)

At the Foot of the Acropolis: A Study of Lawrence Durrell's Novels
by Robin Rook (The Delos Press, 1995)

Too Far to Hear the Singing: Poems by Lawrence Durrell
selected with a Preface by Françoise Kestsman Durrell
(Greville Press Pamphlets in association with The Delos Press, 2005)

Paris Revisited by Anaïs Nin
edited with an Afterword by Karl Orend, with 58 pages of photographs
(New Special Edition, The Alyscamps Press, Paris, 2011)

Autumn Gleanings: Corfu Memoirs and Poems by Theodore Stephanides
(includes Stephanides' recollections of meetings with Lawrence Durrell in
Corfu, Athens and Egypt 1935–1944) edited by Richard Pine, Lindsay Parker,
James Gifford and Anthony Hirst, with an Introduction by Richard Pine
(Durrell School of Corfu & International Lawrence Durrell Society, 2011)

Judith: A Novel by Lawrence Durrell
first publication, Collectors' limited edition, edited with an Introduction
by Richard Pine (Durrell School of Corfu, 2012)

Elegy on the Closing of the French Brothels by Lawrence Durrell
Durrell's poem with photographs, in the form of a large art poster
(The Alyscamps Press, Paris, 2012)

The Placebo: A Novel by Lawrence Durrell
three hitherto unpublished drafts which preceded *Tunc*, edited
and introduced by Richard Pine and David Roessel
(Colenso Books & The Durrell Library of Corfu, 2018)

All enquiries to colensobooks@gmail.com

The
Fruitful Discontent
of the Word

A FURTHER COLLECTION OF POEMS
BY

LAWRENCE DURRELL

EDITED BY

PETER BALDWIN

Printing his dreams among the olive glades
In orchards of discontent the fruitful word.
Lawrence Durrell, from "Besaquino"

COLENSO BOOKS
AND
THE DELOS PRESS
2018

This collection first published May 2018 by
Colenso Books
68 Palatine Road, London N16 8ST, UK
colensobooks@gmail.com
and
The Delos Press, Birmingham, UK

ISBN 978-0-9928632-7-2

Printed and bound in Great Britain by
Lightning Source UK Ltd
Chapter House, Pitfield, Kiln Farm,
Milton Keynes, MK11 3LW, UK

CONTENTS

Where Lawrence Durrell has not given the poem a title, the first line of the poem has been used as its title for the purposes of this collection (in quotation marks below).

INTRODUCTION

The aim of this selection is to make readily available poems published by Lawrence Durrell in his lifetime and generally published after the *terminus ad quem* of the near definitive *Collected Poems 1931–1974* published by Faber and Faber in 1980. Whenever I go travelling for more than a day or so, that *Collected Poems* is invariably part of my luggage and I am regularly frustrated by the absence in that book of the significant body of poetic work published by Durrell after 1974. Some have argued that in his later years Durrell suffered from a falling off of his gifts as a poet. This collection belies that view.

The 1978 travel book *Sicilian Carousel* treats us to some beautiful poems which should not be overlooked, as does Durrell's *hommage* to Provence, *Caesar's Vast Ghost*. All those poems are prime candidates for inclusion in this book which stands, I hope, as a sort of supplement to the *Collected Poems*.

In 1969, Faber and Faber published *Spirit of Place: Letters and Essays on Travel*, still available with the variant subtitle *Mediterranean Writings*. That collection of letters, essays and extracts from early novels reprinted several poems which I feel worthy of inclusion in this book. The decision on worthiness is subjective; all I did was imagine Durrell's reaction to a request to put poems from *Spirit of Place* in this book and assume, for the sake of those now included, his agreement.

This collection does not claim to be the result of exhaustive research along the lines undertaken by the late James A. Brigham, the editor of the 1980 collection. Dr Brigham had 'collected and indexed the whole of my published work', Durrell wrote in his Preface to that collection.

I have neither the time nor the research skills to match Dr Brigham's peerless work. Conversation with Anthony Hirst suggested that a collaboration between Colenso Books and my

Delos Press imprint would bear fruit and this book is a result of both my desire to see these poems readily available in a single volume and Anthony's skills and experience as publisher's editor and book designer. It is, indeed, a delight to work with him to promote Durrell's work.

I have included some poems from Durrell's final novel sequence, now known as *The Avignon Quintet*. Whilst it must be borne in mind that these poems were not written for separate publication, I felt that the assembling of this collection should be an opportunity to include the most lyrical of those poems. The test for their worthiness for inclusion here is the same as the worthiness test for *Spirit of Place*.

I had the privilege to enjoy some long conversations with Durrell in his home in Sommières, near Nîmes in the Gard, France. I came away from those conversations thinking that what he said to me was echoed loud and clear in this last novel sequence. The poems published here from the *Quintet* have been chosen, by and large, not only for what they tell us of the inner Durrell, but also for what I believe they show Durrell wanted to tell us of himself through these poems.

I have always felt that the experience of literature is one which allows one a greater connection with the Real, whatever that is. A few minutes in the company of the 'real' Durrell (who saw himself as primarily a poet) through the medium of his poetry in the 1980 *Collected Poems* is an enriching experience. The purpose of this slim volume is to add to that experience.

The publishers would like to thank Michelle Thomas for her hard work in preparing a typescript of this book from photocopies as they first appeared in published form.

Peter Baldwin
Birmingham, England, March 2018

POEMS

FROM

Spirit of Place

Letters and Essays on Travel

EDITED BY ALAN G. THOMAS

(LONDON: FABER AND FABER, 1969)

*The dates without square brackets appended to the
poems from* Spirit of Place *are those which appear
in the book; those within square brackets have
been added by the Editor as dates of composition
on the basis of evidence within the book itself.*

from

Spirit of Place

A LYRIC OF BODIES

What sweet white meat our bodies are
Who have no canon but delight:
Such pretty devil's food —
O! daintier by far
(We triflers in a foreign night)
Than all those delicately-tended meats
That weight the tables of the rich.

Angels have little meat in them
But vague and evanescent shapes
Declare the wise
Who hoard their comforts up for paradise.
Are we then brutes, my dear, or hinds
Who for refreshment can devise
A sport so rich, a food so able
That soul, a gracious wedding-guest
Waits at the body's table?

Corfu, 1935

EZRA

C-git Ezra
Who knew ten languages
 But could not choose
When writing English poetry
 Which to use.

[1935]

W. H. DAVIES : 'COUNTRY NEWS'

A bed I have
 So white and straight.
All night I lie
 And copulate.
A mirror on
 The mantel-shelf,
So I can lie
 And watch myself
While I am warming
 To my task.
What more can any
 Poet ask?

[1935]

CARD-PLAYERS : STILL-LIFE

Observe then with my eyes what I have seen.
Remark the small inn asleep among olive-boughs:
The curtain of scavenging flies,
Like hanging beads, in the doorway: and men
Snoozing against an olive-bole or playing
Slow, greasy cards. Thumbed colours of conquest.

At their backs, stacked up under the wall,
Long rows of formal melons in sunlight,
Melodious pippins, bright as lighted butter,
Crushed full of juice in crazy sizes
Between black shadow and shadow.

If you could see my scene, would you believe
That men can slough the creeping pale-skinned north
And become one with the afternoon silences,
With the loungers,
The gnomic card-players in a dead tavern
Out of all time and circumstance?

There's no regret here, nor circumspection.
The sun devours these morsels strip by strip
Until we are one among the brown men,
The respectful snoozers in hats of straw.

Nothing, nothing is vocal now, nothing's to say —
Unless the melons burst their heavy cheeks
And dither in the dust, in uproar,
Haunting the incandescence of the sun!

Perama, Corfu [1935]

6

OLD
GREEK FOLK-SONG

Old Aegisthus warmed his balls
In Agamemnon's marble halls,
Marble halls, marble halls.

Clytemnestra on the spot,
She said nowt but thought a lot,
On the spot, on the spot.

Put a watchman on the shore,
Just to please her paramour,
On the shore, on the shore.

One day came a puff of smoke,
From their lustful couch they woke,
Puff of smoke, puff of smoke.

'Agamemnon comes' said he,
A-counting of his rosary,
'Comes' said he, 'Comes' said she.

'Lay the table. Make it snappy!'
Thus Aegisthus, far from happy.
'Make it snappy, make it snappy!'

Clytemnestra hatched a plot,
She said nowt but thought a lot,
Thought a lot, *thought a lot.*

'Agamemnon! what a cough!
Take that soaking armour off!'
What a cough, what a cough.

In the barf-room this prosaic
Wife nailed him to the mosaic,
The mosaic, the mosaic.

Then with minds for words too full,
They sacrificed a cordial bull,
Words too full, words too full.

[1935]

TO ANNE RIDLER

Dear Anne, I have been owing you a letter
From furrin parts — from Ischia, where better
To spin the odd iambic in your name
And tell you something of this island's fame?
We came originally here to see
A character from Prospero called C.
(It stands for Constant) Zarian,
The wild and roguish literary man
Who with his painter wife lives on this island,
A life romantic as one could in . . . Thailand.
Together we have tasted every wine,
Most of the girls (I mean the Muses Nine)
And some small favours accident affords
To such poor chaps as we — as deal in words.
Sure provender of every sort's to hand
For us old roués of the writing brand —
The island is decidedly volcanic,
Quite different to Greece though quite as 'panic',
The soft blue vapour hanging over the bay
Gives tones of blue you don't see every day
While the volcanic rock is all contorted
As if an island goddess had aborted:
But limestones soften into sparkling bays
And geysers everywhere contribute haze,
So soft and sweet and indolent it lies
Under its Naples' picture-postcard skies.
They've lodged us in a wine-press high
On a lighthouse point — a window in the sky
Hidden in vineyards where the sunburnt girls

Shout blithe as parrots in their darkling curls,
Sing bits of opera at me all day
With mad Italian generosity.
So far, however, no real offers of marriage.
If Eve weren't here I would have had a barrage (Sorry!)
Despite advancing years and stoop and paunch —
You get here by a super motor-launch
Crowded with chattering girls from Naples O
Such animation such colossal brio
It makes one feel much younger just to see,
At least so Zarian says. (He's sixty-three.)
He scales a mountain like a wild chamois
Despite a certain — bulk — avoirdupois
And swears Per Baccho loud as any peasant:
Together we've enjoyed a very pleasant
Month of mad cookery and writing talk,
Such food, such wine — a wonder we can walk.
The Master with his silver flying hair
Cooks like a saint and eats like a Corsair,
In octopus and scampi and red mullet,
In hen and hare and cuttlefish and pullet
We've eaten round through past and present tense
Right through the heart of time's circumference,
And now, a week from leaving, in cross-section
I look like — what? Old Mercator's Projection
That used to hang upon the schoolroom wall
And puzzle us when we were very small.
Puzzle no more — as Groddeck says: 'The wish' —
But what imports his counsel when a dish
Floating in some extraordinary dressing
Comes to the table? None of us needs pressing.

This then the sum of all our news is,
Apart from gastronomic self-abuses,
We've bathed and boated and collected pumice,
Lain on the beach sunbandaged as black mummies,
Tasted the salt good Mediterranean blue
Which is as much as we had hoped to do.
Good company, good eating and the sun —
The indulgent patron of this island home
Have all contributed to make the spell
Unbreakable — so leaving will be hell.

Of literary news there is a lot.
Ischia it seems has fast become The Spot.
Capri is finished, everyone is here,
Poets and painters too from all the nations,
And some of curious sexual persuasions.
Among the giants Auden, the great peer
Of all us little moderns, he's acquired
A villa for himself and lives retired;
We've met the great man more than once or twice,
Eve is indifferent; I thought him nice.
A place for exiled writers hating fuss
This seems; why in a little country bus
Jogging to Panza yesterday who should I see
A man I'm sure you reverence as much as me,
Old Norman Douglas, worn as if by sea
Like some old whorled and rubbed-out ocean shell
Still holding shape and life and living well;
Eyes a Homeric blue and hands quite firm,
An air of indefinable ancient charm
Like some old Roman talisman's patina

His Italian pure and deft — I've heard none finer.
But look — the bottom of my second page.
To read this all will take you quite an age;
Time to sign off and tell you we are well
Beneath the ocean-swelling spell
Of *mare nostrum*; how's life treating you?
How is the poetry, housework, knitting, stew?
It is high time for me to take my leave,
And wish you everything from Larry and Eve.

Forio d'Ischia, Ischia
June 1950

LETTER TO ANAÏS NIN

Anaïs, on this smashed and rocking skyline,
Through vermin, cinders, teeth of houses,
We wake and walk like nerves unseparated,
Within the body of our parent, man.

Now unprotected by the skill of lies
Watch in the turbid glass of these canals
Reflected like conceits each others' faces,
By the foul waters of an Egypt's hope.
People who have reached the end of themselves
In new beginnings verify their ends.

We move upon the measure of this hope
Where women and mattresses from windows —
The discoloured tongues of pleasure, hang.

And the romance of open sores — the noble savage
Squats by his waterwheel to worship
And only wakes to piss his barbs and fishooks
Against the politicians' promises.

Here all who find their sweet distraction in each other
By these canals go down in hope
On the green diagrams of land,
Choked with dead leaves and setting sails, find only
Passion that by its own excess divides,
And foreign on the ash-heaps of a city,
Garments for children roaming like the germs,
Fragments of umbrellas, cooking-pots,
The weather did not give them time to try.

A few of us here, a very few,
Are critics of these causes,
Besides the dead, within their snoods of stone;

We move in the refreshment of an exile,
A temperature of plenty served by want
Subtracting nothing in the formal science
Of verse: the art of pain by words in measure.

We ask only
A statement of the nature of misfortune,
That by the act of seeing and recording,
We may infect the root and touch the sin
That the new corn of Egypt springing
From the lean year in a time of triumph
Deliver the usurper from his coffin
And let all that might be begin.

[1952]

POEMS

FROM

Sicilian Carousel

(LONDON: FABER AND FABER, 1977)

from

Sicilian Carousel

MARBLE STELE : SYRACUSE

One day she dies and there with splendour
On all sides of her, for miles and miles,
Stretches reality in all its rich ubiquity,
The whole of science, magic, total time.
The hanging gardens of folly, the aloof sublime,
Just as far as thinking reaches,
Though lost now the nightingale's corroboration
Of spring in meadows of dew uprising.
Only the avid silence preaches.

'Whence came we, blind one?' asks the nursery rhyme,
'And whither going, say?' The cherub questions us
'In the dark of his unknowing clad
He charms eternity, makes all process glad.'
Time has made way at last, the dream is ended
Least said is soonest mended.

Hear old Empedocles as calmly wise
As only more than mortal man can be
Who stands no nonsense from eternity.

'The royal mind of God in all
Its imperturbable extravagance,
Admits no gossip. All is poetry.
There is no which, nor why, nor whence.'

BIRDSONG : ERICE

Rock-lavender full of small pious birds
On precipices torn from old sky,
Promiscuous as the goddess of the grove.
No wonder the wise men listened pondered why
If speech be an involuntary response to stress,
How about song then? Soft verbs, hard nouns
Confess the voice's submission to desire.
A theology of insight going a-begging.

This Aphrodite heard but cared not,
The unstudied mating-call of birds was one
With everything in the mind's choir.
Someone sobbing at night or coughing to hide it.
The percussion of the sand-leopard's concave roar
A vocabulary hanging lightly in viper's fangs.

All this she knew, and more: that words
Releasing in the nerves their grand fatigue
Inject the counter-poison of love's alphabet.

PALAZZI

Cool vegetation, ageless functionaries,
Winter palaces on slimy canals
Folded on green conservatories starred
With time, and all their forlorn flora,
Big dusty plants without their mistresses.
No challenge in the acres of dumb carpet
Sarcophagus of reception-rooms groaning
'Who goes there?' You may well ask aloud.

Further on an artificial lake, forgetfulness.
Neither anguish nor joy obtains on it.

The ancient servant trembles as he points,
A corpse-propelling ninny with bad Parkinson's
Croaks 'Questa la casa' and the silence falls
Touched by the silver chime of clocks,
While soft as graphite or mauve plum-pudding
The recent hills frame cities of the dead, Palermo.

TAORMINA

We three men sit all evening
In the rose-garden drinking and waiting
For the moon to turn our roses black,
Crawling across the sky. We mention
Our absent friend from time to time.
Some chessmen have tumbled over,
They also die who only sit and wait
For the new moon before this open gate.

What further travel can we wish on friends
To coax their absence with our memory —
One who followed the flying fish beyond the
Remote Americas, one to die in battle, one
To live in Persia and never write again.
She loved them all according to their need
Now they are small dust waiting in perfect heed,
In someone's memory for a cue.
Thus and thus we shall remember you.

The smoke of pipes rises in pure content
The roses stretch their necks, and there
She rises at last to lend
A form and fiction to our loving wish.
The legions of the silent all attend.

AUTUMN LADY : NAXOS

Under spiteful skies go sailing on and on,
All canvas soaking and all iron rusty,
Frail as a gnat, but peerless in her sadness,
My poor ship christened by an ocean blackness,
Locked into cloud or planet-sharing night.

The primacy of longing she established.
They called her Autumn Lady, with two wide
Aegean eyes beneath the given name,
Sea-stressed, complete, a living wife.

She'll sink at moorings like my life did once,
In a night of piercing squalls, go swaying down,
In an island without gulls, wells, walls,
In a time of need, all stations fading, fading.

She will lie there in the calm cathedrals
Of the blood's sleep, not speaking of love,
Or the last graphic journeys of the mind.
Let tides drum on those unawakened flanks
Whom all the soft analysis of sleep will find.

BESAQUINO

No stars to guide. Death is that quiet cartouche,
A nun-besought preserve of praying-time,
That like a great lion silence hunts,
At noon, at ease, and all because he must.
His scenery is so old,
His sacred pawtouch cold.

A lupercal of girls remember him
In nights defunct from lack of sleep
Tossing on iron beds awaiting dawn . . .
He wound up his death each evening like a clock,
Walked to obscure cafés to criticise
The fires that blush upon the crown of Etna.
Leopardi in the ticking mind,
Lay unknown like an exiled king,
Printing his dreams among the olive glades
In orchards of discontent the fruitful word.

POEMS

FROM

The Avignon Quintet

SELECTED FROM THREE
OF THE FIVE NOVELS

Monsieur or The Prince of Darkness (1974)

Livia or Buried Alive (1978)

Quinx or The Ripper's Tale (1985)

(LONDON: FABER AND FABER)

from

The Avignon Quintet

"WHAT A MYSTERIOUS BUSINESS"

What a mysterious business.
Wound up one day like a clockwork toy
Set down upon the dusty road
I have walked ticking for so many years.
While with the same sort of gait
And fully wound up like me
At times I meet other toys
With the same sort of idea of being
Tick tock, we nod stiffly as we pass.
They do not seem as real to me as I do;
We do not believe that one day it will end
Somewhere on a mountain of rusting
Automobiles in a rusty siding far from life.
Pitted with age like a colander
Part of the iron vegetation of tomorrow.

"GRIEF CLOTHED IN DAYS, IN HOURS"

Grief clothed in days, in hours
In places things and situations
Grief thrown out of the trains
Or emptied from sturdy dustbins
Overboard from ships in sea-cremations
From eyes or lips or refuse-tips
Sliding like coals in chutes
Grief thrown into disuse by miner's time
A dustbin full of memories' old disputes
And then to see sorrow come with its
Stealthy foreclosing, final demands, the grave
While super-silence hovers like a nave.

"LES GRANDS SENSUELS
AGRÉS COMME MOI, ROBIN"

Les grands sensuels agrés comme moi, Robin
Les sensuelles es Amour comme elle
Dans des jardins d'agrément jouant
Comme des poules dans les basses cours
Sont plutôt agronomiquement acariatres
Selon les pédérastes, les putains et les pâtres.

Mais ce soir si ce joli temps permet
Si l'equinoxe persiste
Nous allons entendre chanter tous les deux
La petite doxologie des toiles d'arraignés.
Éplucher le gros oignon de l'univers
Nous deux cachés par l'éventail de la nuit.
Écoute, c'est le temps qui coule
C'est la nuit qui fuit. A moi Bouboul!

"I HAVE SHIFTED THIS
HUGE WEIGHT"

I have shifted this huge weight
By only a hair in half a lifetime
Of dead breath and sinew, to somewhere else,
Merely a shift of weight, you'd say,
Though it might be heavier than air
But slow to grow as mammoth's teeth or hate,
A lifetime of nails growing on after death;
Yes, I have moved this huge weight,
By less than a weightless breath
And with it the weight of my afterlife
And massive, the weight of your death.

BURIED ALIVE

For Livia

A poem filling with water,
A woman swimming across it
Believing it a lake,
The words avail so little,
The water has carried them away
Frail as a drypoint the one kiss,
Renovation of a swimmer's loving.

Attach a penny calendar to the moon
And cycle down the highways of the need,
The doll will have nothing under her dress;
With an indolence close to godhead
You remain watching, he remains watching.

When she smiles the wrinkles round her eyes
Are fitting, the royal marks of the tiger,
The royal lines of noble conduct.

Virtuous and cryptic lady, whom
The sorrows of time forever revisit,
Year after year in the same icy nook
With candles brooding or asphodels erect,
Stay close to us within your mind.
Those winter loves will not deceive,
Unplanned by seasons or by kin
They feast the eye beneath the skin.

"TO EACH HIS TUFFET"

To each his tuffet
And to some Miss Muffet.
(Many are called but most are frigid.
Some need theosophy to keep them rigid.)

Deep in its death-muse Europe lay.
Boys and girls come out to play.

Fruit de mer beyond compare,
Suck a sweeter if you dare.

Ashes to ashes, lust to lust,
Their married bliss a certain must.

He storied urn, she animated bust.

"TIRESIAS, THE OLD MAN, WEARING TITS FOR EYES"

Tiresias, the old man, wearing tits for eyes,
Deep in his vegetative slumber lies.

Her voice lives on in memory
A bruised gong spoke for Livia
Lessivée par son sperme was she.

In the Hotel Roncery the slip hatch
Into Grévin with its wax models
Showing more pure discernment than intelligence.

Sutcliffe took the Prince on a binge or
Spree — a pig in clover he rolled about in
A garden of untrussed trulls.

A sex in her sex like an alabaster dumpling!
Her knickers smelt of gun-cotton, a
Moth-bag of a woman shedding rice-paper,
Powder, cigarette ash and paper handkerchiefs
Which she had twitched once about her lips.
A characteristic groan as he paid in coin.
You'd have been surprised by the tone
He took, the young Catullus with Julius Caesar;
A Tory untrussing a parvenu, dressing down
A political bounder, a tyke. Then later,
A heart shedding its petals, Latin verse.

" I MARRIED A FAIR MAID "

I married a fair maid
And she was compos mantis,
We bought a third return
On a voyage to Atlantis.

'Happy New Year!' The roysters cried
While clowning clones their cuddles plied.
Gaunt Lesbians like undusted harps
Hung up their woofs and coiled their warps.
Woof to warp and warp to whoof
They like their whisky over proof.

And so one day we
Reached Atlantis,
Outside all peacock
But inside mantis
Ecco puella corybantis
Primavera in split panties!

POEMS

FROM

Caesar's Vast Ghost

Aspects of Provence

(London: Faber and Faber, 1990)

Caesar's Vast Ghost

CONSTRAINED BY HISTORY

To thank Mary J. Byrne for her collaboration

1

Constrained by history, now he shall not make
New friendships or attachments
For the circle of the old is closing in . . .
He will simply get beyond the need to explain
How his bounds were set by his mother's dying,
How his comet rose from the coffin of his father's striving:
Lucky indeed is he to have come so far alive,
In an epoch of wars, waging only total peace:
No luckier than to inherit the Golden Fleece.

The secret of whose code engenders peace!

2

He will cure his feelings on the world as threat,
Knitting poems from them, true and mouse-compact;
Find a tellurian delight in the sweeter
Arrow-faithful love-act, having been half girl
And boy, husband and wife in the ancient love-contract.
By the belly-button of Tiresias he will swear,
Or the pineal eye, the pine-cone which made him first aware

Of everything outside the bazaars of the mind.
Only to seek, they said, and ye shall find!

The thrilling yoga of love's double-bind!

3

Beyond the gossip of the senses' codes,
He'll become at last one of the Heavenly Ones
Who smile and wage silence up there, finger to lip,
With their help he will give time the slip
And join them soon in their heavenly abodes.
Great mysteries undivulged must always be,
Housed in their silence undeviatingly;
Though you a whole infinity may take
You'll not unravel the entire mosaic.

4

One link, the couple, only death can sever,
Conflating man and wife now and for ever.
Old men with ocean-going eyes, fully aware,
Smelling of camp-fire wisdom, the elect,
Their world of shyness beckons like a snare,
Their silence something we can not dissect.
They know, we know, the stealth of human prayer
Whose poisoned fictions beg for our consent,
Reducing loving to this point-event,
Makes here and now a simple everywhere
The human heart was well designed to care.

5

So now all time is winding down to die
In soft lampoons of earthly grace set free:
She is not far to seek, your Cupid's sigh,
Forms like old caryatids of ruins to be
Genetics of the doubts love cannot free
In you awake tonight, my love, awake like me.

SOMEWHERE NEAR ST-RÉMY

A garage in such a village, say,
Run by a Claude Girofle
And one pig-tailed daughter, Espionnette,
Who mans the pumps with fervour,
Ici on vous sert,
Ici on vous berce!

The souls of temple cats
Eyes like vitreous bubbles
Blown in glass, gypsy eyes,
The faces Plato calls 'of a demonic order'
Demons disturbing liquid flame.

Unaware of the Druids' ancient charter,
The magical primacy of wishing,
The glands of fire,
Sunshine has carried love away —
At full moon everyone seems right
Or so the water seems to say,
The wanton Pleiades pining for the day!

ROUTE SAUSSINE 15

Only of late have I come to see this house
As something poisoned when I paid for it;
Its beauty was specious and it hid pure grief.
Your absence, dearest, brings it no relief.
We have all died here; one by spurious one
Of indistinct diseases, lack of sun, or fun,
Or just our turn came up, now mine; so be it, none
Decline into oblivion without a guide,
The last of maladies, death, love can provide
The abandoned garden, dried up fountain oozes,
A stagnant fountain full of tiny frogs
Like miniature Muses; say to yourself
No hope of change with death so near.
Days come and sigh and disappear.
Despair camps everywhere and my old blind dog
Though lacking a prostate pisses everywhere.

PUNKS
AT THE PARTHENON

We have never loved anyone
Or believed in anything wise:
And for some time now
Have come to believe we are
A variety of mutinous angel
Candid and absolute in our nothingness.
Goaded by soft unreason to despise
The tumble-dried life of modern love.
'As above, so below,' says the prophet.
'An ego poached in salt . . . means WOE.'
An acropolis of broken teeth beckons.
Yet three of such kisses and you are hooked
As we say in heroin lingo, hooked!
Between conniving thighs an addict lies,
To lead you by syringefuls to the land of sighs.

SLEEPWALKERS

One rapidly cooling corpse ago
He heard his mother's angel go
On tiptoe in memorial guise,
Finger on lip, smiling and wise,
Finger on heart, thoughtful and slow,
She sank the knife home to the hilt:
He felt the polar stab of guilt.
This was her way of saying No.
The treason was too much to bear
In his heart's core. Ah! Woe!
It slept gothic-nefast and sure
Kiss of some old Slavonic whore.
'Eh bien,' he thought, 'Je suis bien servi
For daring to believe us free';
When Adam toiled and Eve span
Who was then the gentleman?

FERIA : NÎMES

Feria; cloaked trigonometry of hooves
The plane trees know, shiver with apprehension;
They plead as the archons of the blue steel must
These prayers, refining murder by a breath,
Turn self-deception to an absolution —
Two coloured pawns uniting in the rites of death.

Brocade still stiff with bloody hair he kneels
While the mithraic sun sinks in a surf
Of bloody bubbles; leads from the huge pizzle
The holy urine smoking in the dust.
He reels into a darkness which he dazzles.

Tall doors fall as the axes must,
And the great sideboard of the bull is there,
A landslide in the ordinary heart
A feast for gods within a coat of hair,
His thunder like a belfry and his roars
The minotaur of man's perfected lust,
His birth-pangs offered to the steel's applause.

WHY WAIT?

Primaeval Camargue horses under sail,
Stealthy as wishes or as secret agents
Curve under Roman monuments, vibrate,
Appropriate to sky as water, sympathetic
As ruins which insist in their serenity
All time could be compressed
Into one pellet of ample duration because
The first step towards creation is to lose
Complete confidence in oneself and sort of die.
I know . . . I see you smile. Accelerate loving.
Remit the old codger's deathbed flutter. Try!
Somehow copy the sweet conduct of these
Young olives in the spring mistral a-quiver
Silverside up with such panache and
Colloquial astonishment in sunset poses.
Join the great coven of real lovers, the
Conspiracy of lovemates forged in debonnaire
Realized couples like perfected machines
Guided by love-placebos from the wise
 Only realize! Go on! Be wise!
 Yes but how?
They are caressed by oncoming night
With all their nightingales in lovely voice.
And this superb Roman lady asleep
Has the whole pedigree of pure happiness
Delicate as young olives, their pigments,
Loose-leaf in slumber in her smiles.
One becomes sorry to become so soon
Just luggage left like lumber,

Just after-thoughts of inexcusable grace
Posted up by a love-god's outlandish looks,
A love-seraphic smiling face.
Did not the proverb say explicitly
'Never try to whitewash a silk elephant'?
And (beyond all where or why):
'In yoga harness a whole reality with one soft sigh.'
A vessel in full sail
With a weird mystical rig
Will tell you once and for all
What the Greek proverb says is true:
'Happiness is just a little scented pig.'
It's not enough but it will have to do.

LES SAINTES

It has rained all night on the lake
Until the swans burst out in uncontrollable
Sobs of pleasure and the vertical
Summer moon arrived on cue —
So much explicit wonder soft as silk:
Consenting adults expressing lively doubts,
Lovers with time, and not enough to do!

Here I am, lost in wonder at the self-evident.
Anointed by vexations — alone!
The hardest thing is to get used to the thought
'It had to happen this way and no other!'
Why not then this beautiful available whore?
You could die in such arms with no loss
Of carnal self-respect. Ask for Cunégonde!
She comes with a rope and nothing more,
Thirsty for pre-eminence like all her tribe,
The carotid caressed prepared her for the stake,
Genetics of a human doubt or loss of hope
Is something we could do without or slake
Defunct punks buried with disjunct monks
A PhD in sorrow paid in full by time.
The town clocks mark the hours chime by chime
As chunk by chunk they bury liquid time.

Editor's Note: Cunégonde, a character in Voltaire's novel *Candide*, is the name borrowed by Durrell as one of his "masks" through whom he spoke many of his ideas. Please see Durrell's Author's Note to his poem "Conon in Exile" (*Collected Poems 1935–1974*, London, Faber and Faber, 1980, p. 107) and, for a comprehensive explanation of how Durrell incorporated Cunégonde into his writings, the final chapter of *Caesar's Vast Ghost*. And in the present volume see the poem "Cunégonde, his only love" (below, p. 56).

TRINQUETAILLE

Encouraged by red wine, at Equiconque,
Fête votive of a Roman village on water
Cartoons of human licence at play
The dancers hairy cherubs, thimbles for lips
Infatuated by this glorious termagant
Her mass of blonde tragedienne's spitcurls
Worn like a ponytail, parted lips and thighs
Fecundity without blemish, kisses in hot wax,
Her partner a mock-up of urban man
A horizontal giggle bursting its banks.
The important thing you felt was: learn to hesitate.
 Dancer!
Kept alive on placebos in his prime
The old love-boobies, laureates of lust,
Eros amans, his boy-love is a must,
Deaf in one eye, the sacred Third,
Blind in one ear he dances in the dust
All the secret histories make it clear
Caesar was once happy here.

ARLÉSIENNE

Opening a corrida thus
Seven black beauties
Riding side-saddle proudly
Among our Roman ruins
Fresh from the Courts of Human Love.
Their lovely hair a simple nest
For violets and lace,
The smart little cap à pie
And when you see the
Galloping swerve of these
Human rainbows you realize
How nothing is really dead
 But
Everything just thinks and waits and knows.
 Yes but
Why or what or for whom?
 Surely
For the black Iberian sacrificial
Bulls, thunderbolts of pure sensation.
They await the cruel preaching steel.
Their blood will smoke in the dust
Predestined for catastrophe they lounge
In darkness wait for the female sword.

THE RHÔNE AT BEAUCAIRE

Precision of a new day lifting through vines
To reflect its blue, the shameless pretext
Of its flowing water like a slang
The priapism of the jungle gone to seed,
Witty with promise of harvests to come
The poet's great laboratory and creed
The word which flows on stanchless as human need,
Or the river, rhythms of memory traced in the blood
So graphic yet so untranslatable to others:
Your beauty, Françoise, the Rhône at Beaucaire.

PRINCESS X

A Russian Amazon who bruises minds
And gave me a sore memory blitz
Awakes these graphic lines —
Sometimes insists on looking like
A sick mule, or a mutinous cherub
Cocotte-minute and camisole de force in one,
At others like the down draught
From the furnace of a love-machine,
Cheeky groom that everyone would shun.
She was for me a gorgeous python
In a nightdress of monkeys' skulls.
She ushered death in, the perfect go-between,
Beautiful in her harmony of pearls
She loitered with smiles among her naked girls.
A necklace of rats not all of them dead,
She wrote her poems for the most part in bed.

FLOODED NÎMES

Goblins in rubber that seem so torpid,
Like Hitler's mother in the last photo
Perched on his breast, only the medals showing.
A love bewitched by the classical fraud of Freud,
The personal neurasthenia refined by death —
Greet the dead with the music of shovels,
Or the cellars of Roman Nîmes full of dead cats
Afloat with giant rats feasting on garbage,
Rats the size of human heads in car parks
Built for the higher tourism and its clients
Floating about in the dark fully dressed
At the wheels of their expensive cars,
The wingbeat of crossed eiderdowns at night
By floodlit garages — A nymph with all her rivets showing
Sweet primate of a summer night farewell.
We'll scold the human heart for loving too well.

GRAND CANAL

Old men cry easily and wet their beds,
Incontinent in their dying as crowned heads
Death's keyhole they confront like newlyweds.
Peach-fed survivors in their coffins of grace
They meet to mock their Maker face to face!

Resolve the chimera of free choice while we
Steadily become what we believe,
The discrete ego is our fatal fallacy
Hamlet dispensing his 'to be or not to be'
And by the lantern of the finite mind
Set out to discover only what we find!
Nature's cruel version of Kant's double-bind.

If I must die in your welcome embrace
Bury me in this body half-asleep,
Woebegone, yes, but heartwhole, just to keep
The hounds of smiling passion in full cry.
Safe on the raft of your lovely body drift
Down through Mediterranean sigh by sigh
The spars of leaven-gold limbs spread wide
A pavilion of loving forms in postures meek
All night as Venice, monogram of the Holy Ghost, sails by.

BÉZIERS : ROSES, RIVERS, RAIN AND RUINS

So death *ad hoc*
Or love *ad lib*
And memory *da capo*
To get back what you give.
With the taxonomy of lust,
Doctors so keen on being right.
'I think therefore I must
Before the poor survivors turn to dust!'

But once the circle of initiation closes
A death-begotten insight rules,
Rough harness of the old anxieties,
Offer their trivial psychoses,
Models for human fools.
But most of us after the fatal
Déclic, thrust of the love-mind,
Will go on living paranormally
A post-humous life so to speak to find
In some cold garage of a human love,
Full of defenceless corpses smiling up,
Already embalmed and sailing away
So blessed are the meek, so limitlessly weak,
The ruins of the moon pressed cheek to cheek
'I love, wherefore should I seek?'
Smiling through children's tears they seem to say.

VISITING ORANGE

All airs and graces, their prevailing wind
Blows through the tapestry to stiffen
The fading girls, complexions of tea-roses,
With pets upon provincial laps
And hair combed back against the grain
In innocent professional poses
Sit centred, watching time elapse.

Scented abundance of black hair built back
In studied rolls of merchandise to loom
Over strangers' visitations: ladies of pleasure.
Their musical instruments are laid aside,
Oh! lethargy of educated leisure
That palls and yawns between these silken walls.
But one, luckier or younger, stands apart
On a far bridge to enjoy a private wish,
Casting the aquiline fishing-rod of gold
Angling for other kinds of fish.

BLUE LIGHT AT DUSK

Set me a parody of this small island town
Recalled in silence, birthmark of old memories,
Benchmark of a Roman slave in an oar blade
Not only beautiful but proposing also
To satisfy every human need like church,
Tavern or brothel — blue light at dusk;
Houses of pleasure in coloured bulbs,
Brief as grief but warm as all charity.
Someone born for the inhuman act of love
Between the horns of Minos, yes, pure terror!
Defended by one ikon of her saint,
'Only a whore,' you said: but with the sagacity
Of some great Muse, some great jurist, Marina!
The behaviour of silence is quite artless,
Sleep closing like a door, absolved by kisses.

Yet the smartest and best of the lovers for money
Was Minerva, secret of her freshness the two
Musk-melons kept between her thighs in summer,
Keeping cool as spice the human fruit — ourselves
Engendered love in silence like a young polar
Cleopatra gone to seed, yet garnered sigh by sigh.
To humour the dead in August when you die most;
Detectives of the worthless human kiss,
Your currency of love must end like this,
Blue grief at dusk and some quiet love
At cockcrow with the ruins of the sky.

STATUE OF LOVERS : AIX

Roasts on in ageless loneliness, the sage,
All but abandoned by his very sex,
With no such drastic animals to keep
At bay, allows his dreams to vex:
Is troubled by young daikinis in his sleep!

In France poor sputtering Sade presides
On love and smears the wench of time
By tedious repetition — dulls;
Of all experiences the one sublime
(The silent kiss the mortuary confines).

But no dissection could as well describe
The science of this woman's head, the beauty,
Eaten away by siege, by time, by fire,
(Young sorrows incubate in man's desire)
Like sonnets engendered by the rain
Beating on some old poet's hat,
The psyche's pious dimorphism means just that —
Her kiss may never strike again!

"CUNÉGONDE
HIS ONLY LOVE"

Cunégonde his only love,
(As below, so above)
A bivouac in every bed
With sighs enough to wake the dead.

Battle with inadvertent love
'As below also above'
Cunégonde will see you through,
Do not tell her what to do,
She's the original, whom from whom,
Loving was woven on her loom,
Lead her smiling to the tomb.

— ◆ —

My last love was a smiling cramp
She sped the poetry with a gamp,
The coffin was another story,
I wanted nacre for the glory.
Something, I mean, that never fades —
But all they gave me was the 'AIDS.'

— ◆ —

The No Balls Prize for English Lit.
Was given to a perfect fit.
Professor Tangboom filled the bill,
Expressions of the human will,
A drunken comet pissing fire
Could illustrate his heart's desire.

On Cunégonde, see the Editor's Note on p. 45 above.

POEM OF A DISCRETE EGO

In borrowed bodies love commits blackmail:
In forged particulars couples set sail,
With heart-on-sleeve, with love to no avail,
The Damocles of sex their oft-told tale,
With what's the usefulness which must prevail.
Fathom one lover's look and glean the whole
Rebuked by silence with its pure control.

"PAUSE HERE FOR A
DISENFRANCISED SOB"

Pause here for a disenfranchised sob! My rubber wife and I
exchange unexpended tears at night, by the light of a humble
candle on a mountain of ash and dead slag.
Watching all time quietly elapse
Into a sort of great Perhaps
Fluid yet uniform: no gaps
A womb without a real prolapse.

C'est la mort qui grimace tendrement.

Living an a-historical life
Writing love-letters to the world's wife
In invisible ink once you reach the Brink
Watch for the slip twixt fuck and think.

LE CERCLE REFERMÉ

Boom of the sunset gun
In the old fortress at Benares,
And a single sobbing bugle calls
The naphtha flares on river craft
Corpses floating skyward
The thumbworship of the dead
Gnomes with their vast collisions
Of water and weed and light
With the dead awake all night
The coffined dead true in love's despite
The thumbscrews of awareness screwed in tight.

The girl with nine wombs is there to chide
What does it mean, your ancient loneliness?
Today they are coming to measure me for a coffin,
So dying you begin to sleepwalk and regain your youth.

Mere time is winding down at last:
The consenting harvest moon presides,
Appears on cue to hold our hearts in fee,
The genetics of our doubts hold fast
And a carotid is haunted by old caresses
The caresses of silence.
When young and big with poems
Caressed by my heliocentric muse
With lunar leanings, I was crafty in loving,
Or jaunty as a god of the bullfrogs
The uncanny promptings of the human I.
Love-babies nourished by the sigh,

With little thought of joy or pain,
Or the spicy Kodak of the hangman's brain
A disenfranchised last goodbye,
 Goodbye.

INDEX

INDEX OF TITLES
AND FIRST LINES

Titles are in capitals. Where first lines are very short the second line is given too. Alphabetization is by whole word, so that, for example, "A Russian" precedes "All airs".

Lightning Source UK Ltd.
Milton Keynes UK
UKHW01f1633170518
322764UK00001B/12/P